Cute Kids and Their Pets

A Color Therapy Coloring Book

By

Kim Jordan Blair

I would like to thank my good friend Renee Kritzer, for allowing me to use her color version of the little artist on the cover of this book. I would also like to thank her for giving me some suggestions for some of the pictures in this coloring book.

MONTH of DECEMBER

Sunday	Monday	Tuesday	Wednesday	Thursday	Friday	Saturday
1	2	3	4	5	6	7
8	9	10	11	12	13	14
15	16	17	18	19	20	21
22	23	24	25	26	27	28
29	30	31				